Baby, Baby, Sweet Baby

Babies are new and

full of potential.

They have nothing

to hide.

Photographers

appreciate the fact

that babies are not

camera shy.

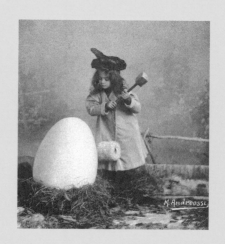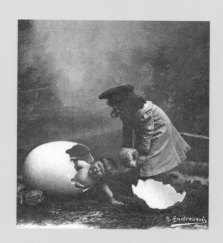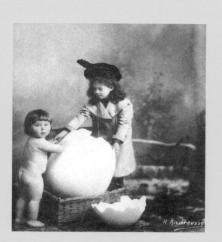

Baby, Baby, Sweet Baby

BRUCE VELICK

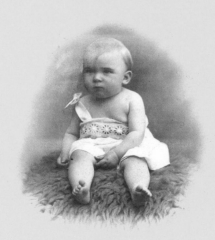

POMEGRANATE ARTBOOKS ◆ *San Francisco*

Special thanks

to those who helped put all the pieces together: my agent, Candice Fuhrman, Monah Getner at Hyperion Press, Laura Strauss at Magnum Photo, Kathleen Grosset at Rapho, Catherine van Haaren, Tom and Katie Burke, Bonnie Smetts and the entire staff at Pomegranate Artbooks.

Published by Pomegranate Artbooks, Box 808022, Petaluma, CA 94975. © 1992 Bruce Velick.
ISBN 0-87654-967-9 LC 92-80853
Printed in Hong Kong
First Edition

To my sweet baby, Denise

Babies are small

but occupy

a lot of space.

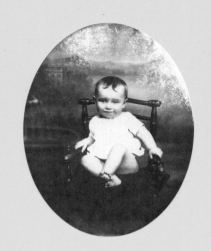

Babies make it known

that they do not like

to be ignored.

Babies will look

you in the eye

(as soon as they can).

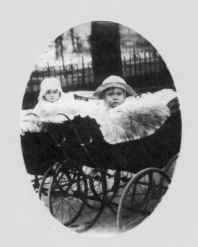

Babies don't mind

if you act

silly.

Babies make good friends:

you can talk to them;

they are great listeners.

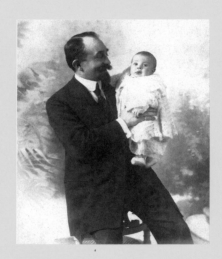

Given their vocabulary,

babies are pretty good

communicators.

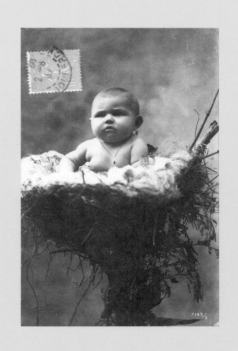

It is very hard

for us not to

relate to a baby.

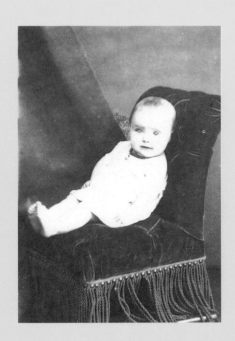

Babies know there is

something special about

brothers and sisters.

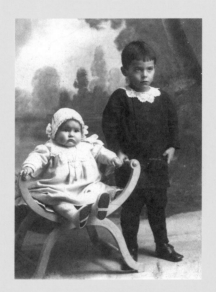

Grandparents know

there is something special

about babies.

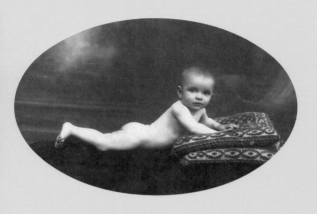

Babies are comfortable being naked.

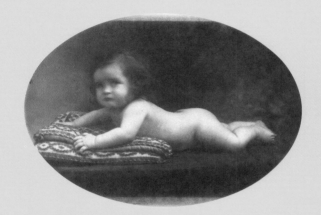

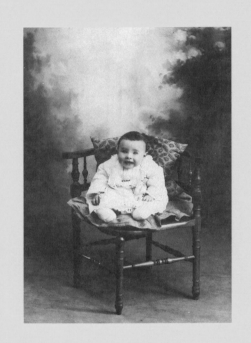

Baby

Sweet Baby

Groping Grasping

Seeing the World Anew

Gurgles and Grunts in Wonderment

Awake Out of Fear of Missing

Something New

My Baby Baby Sweet Baby

So Dependent

on You

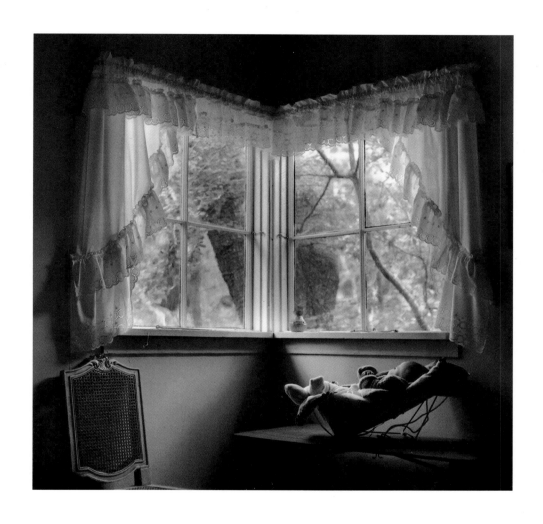

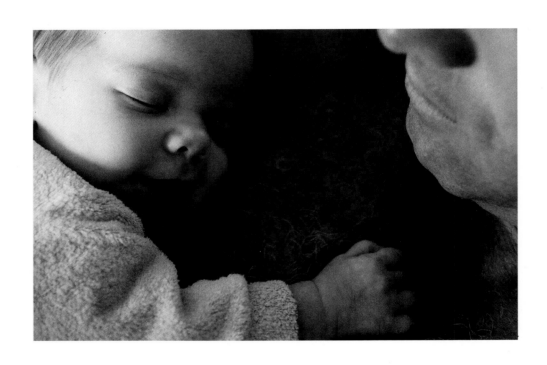

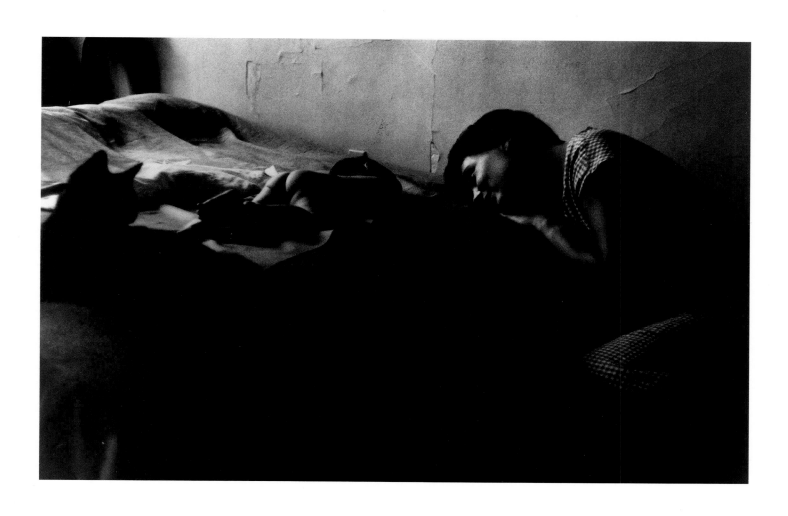

3.

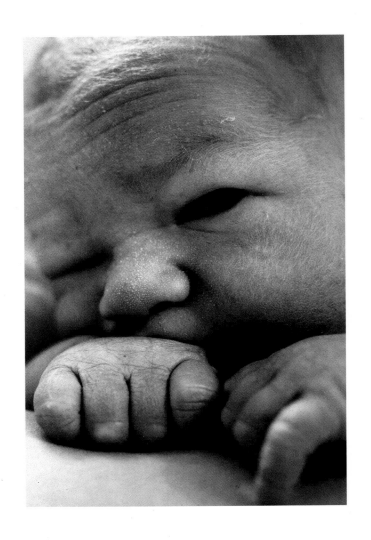

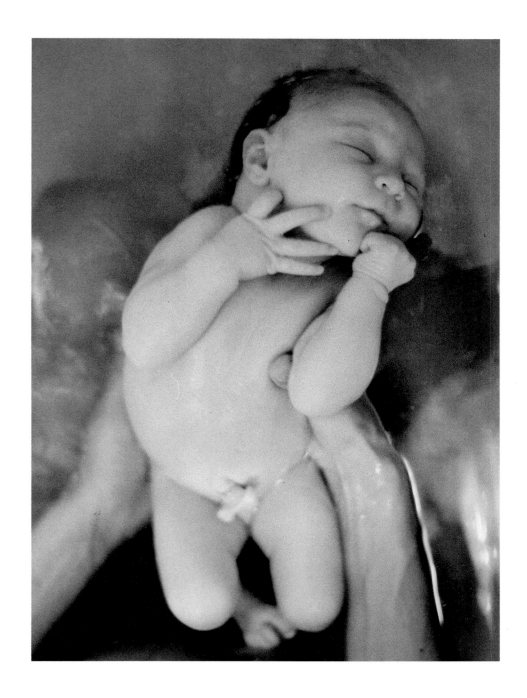

5.

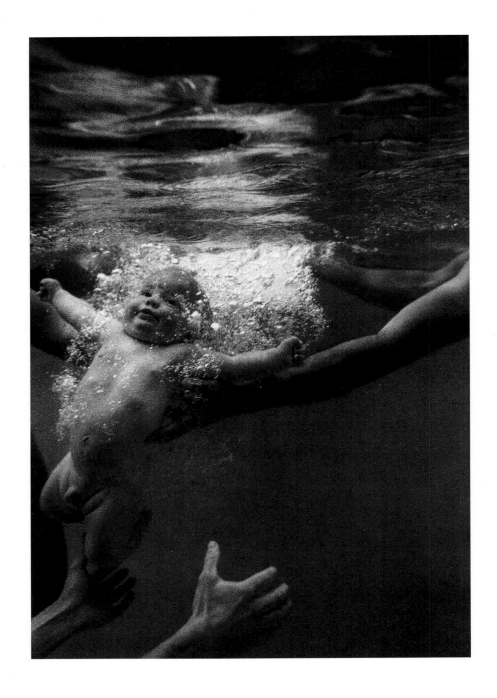

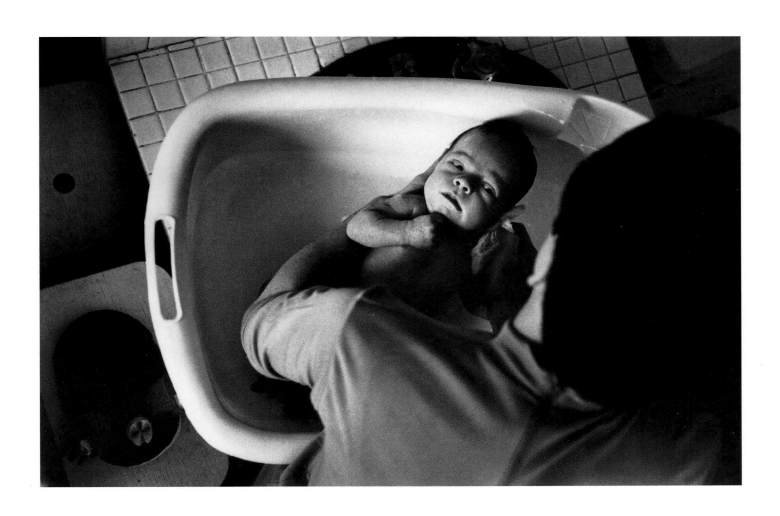

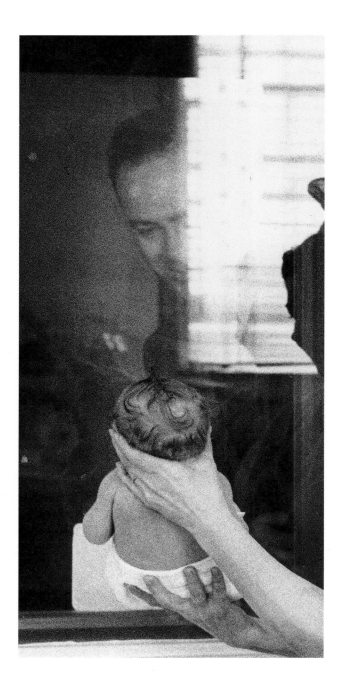

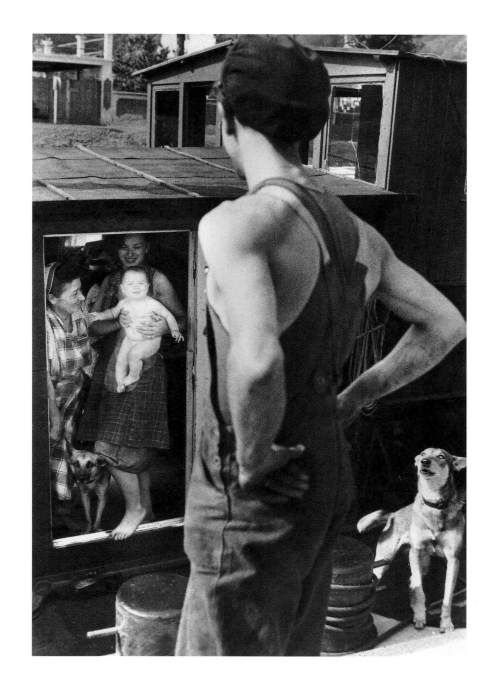

9.

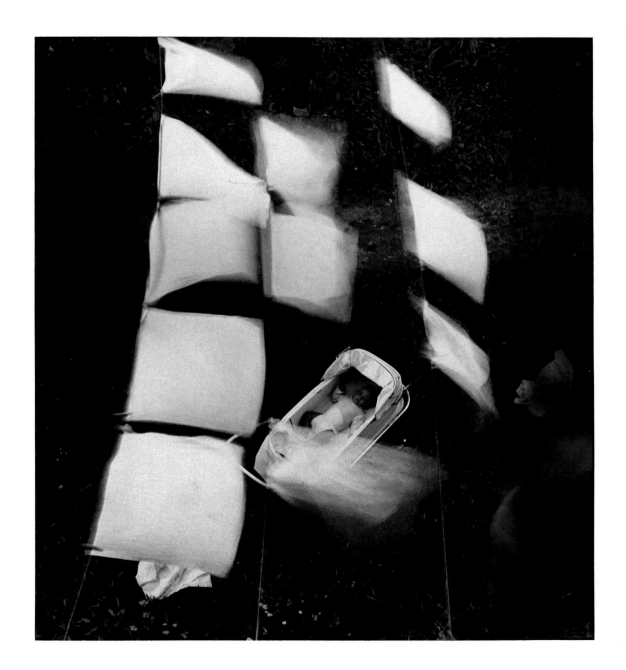

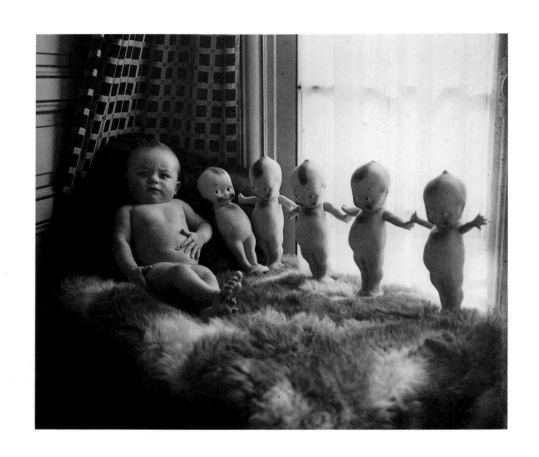

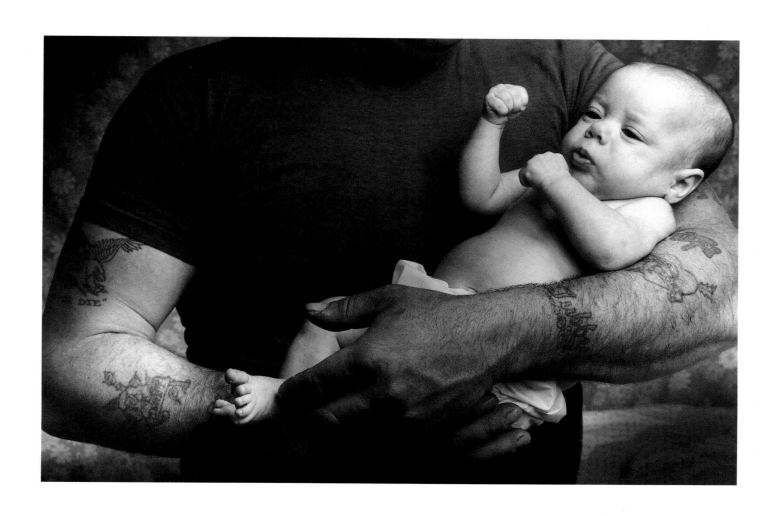

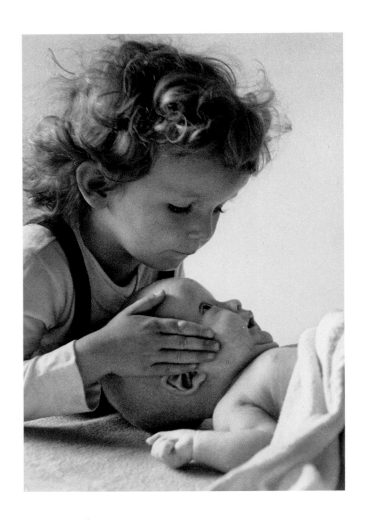

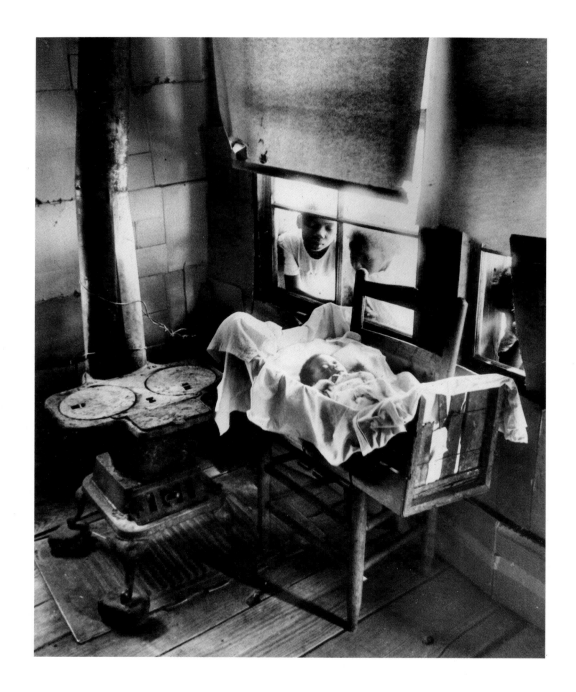

14.

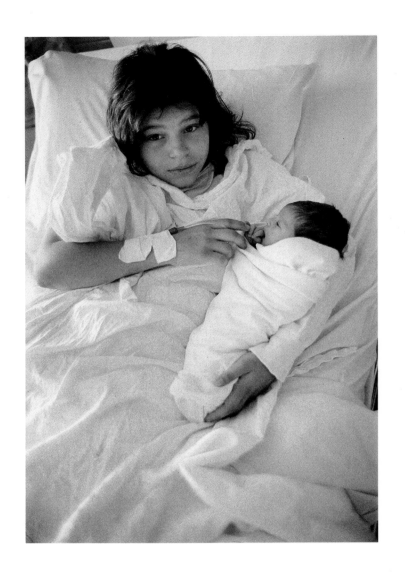

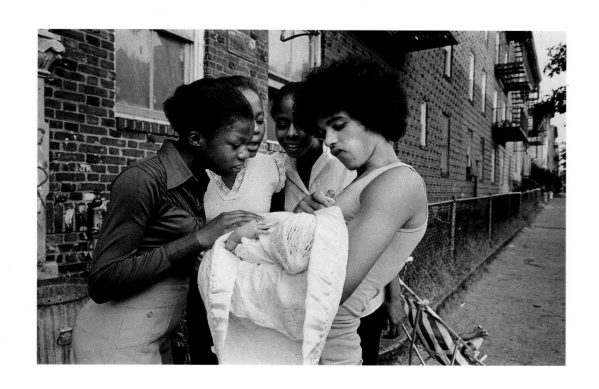

16.

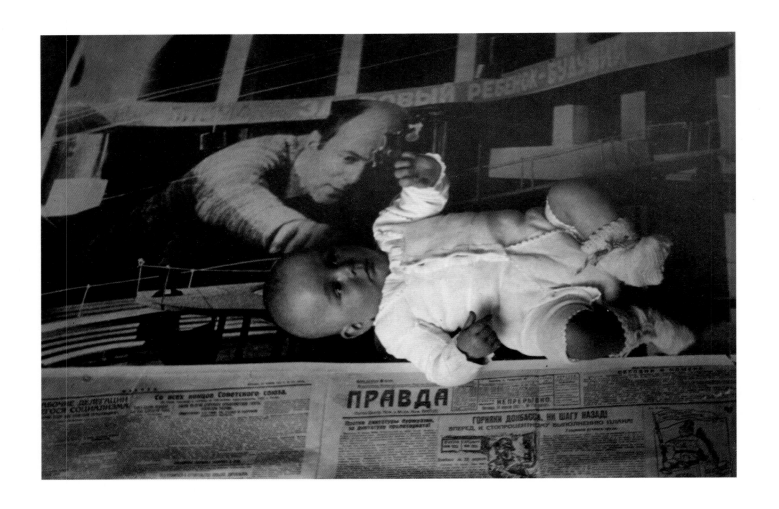

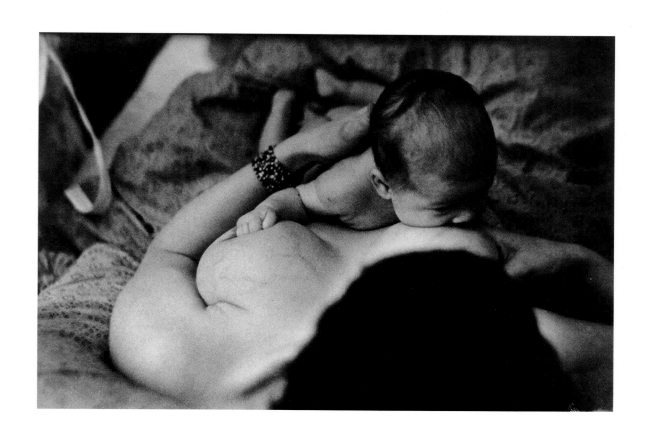

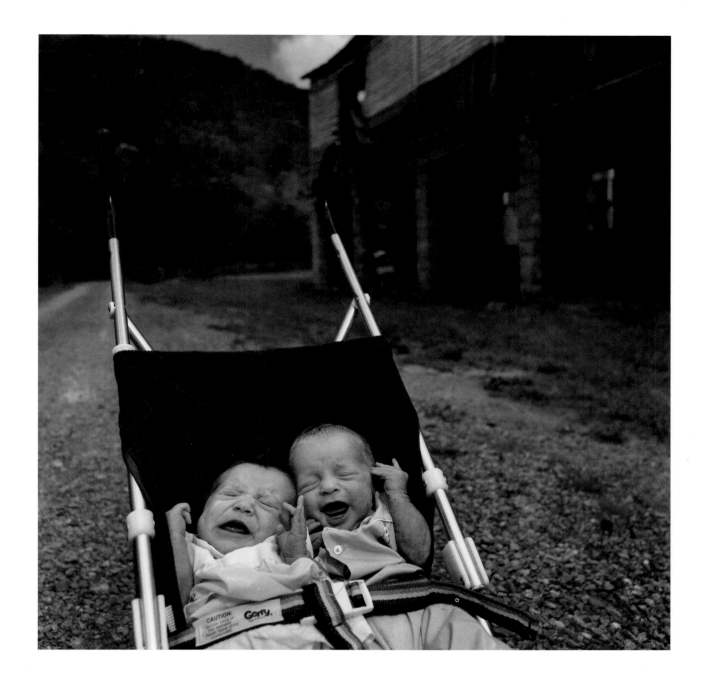

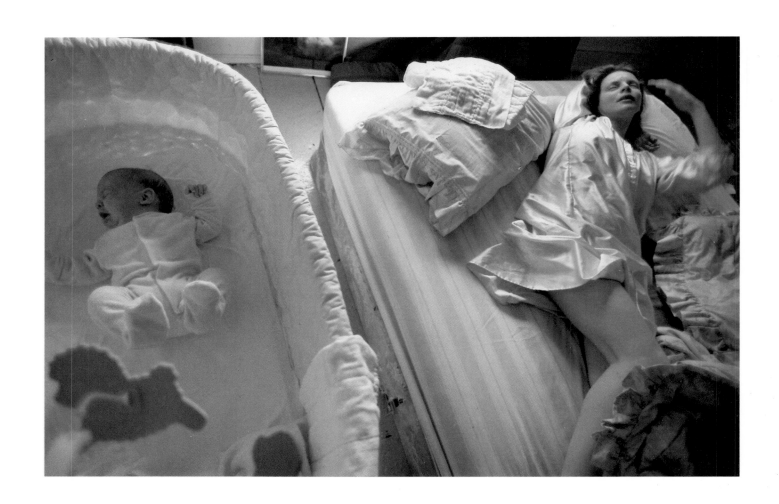

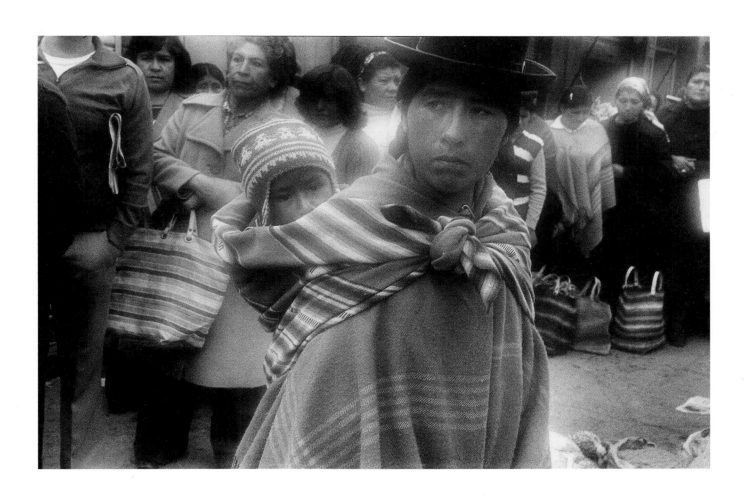

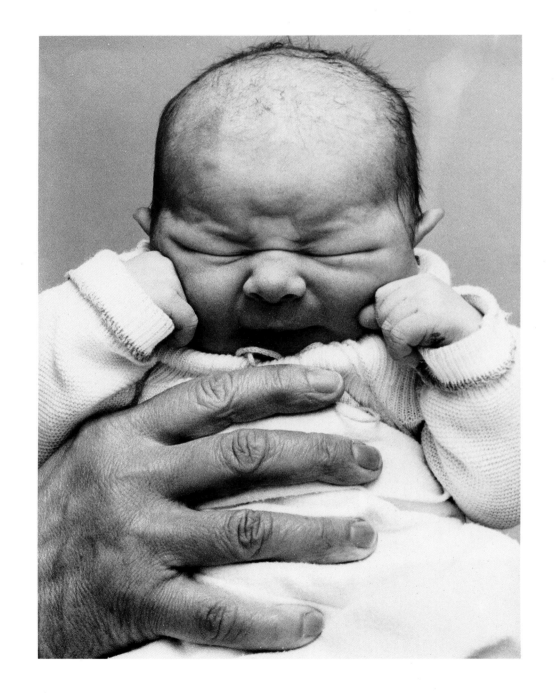

22.

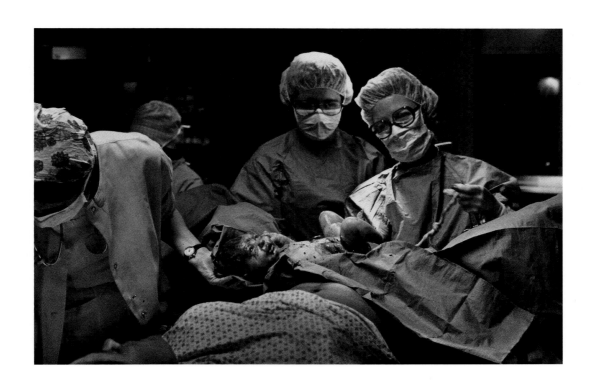

23.

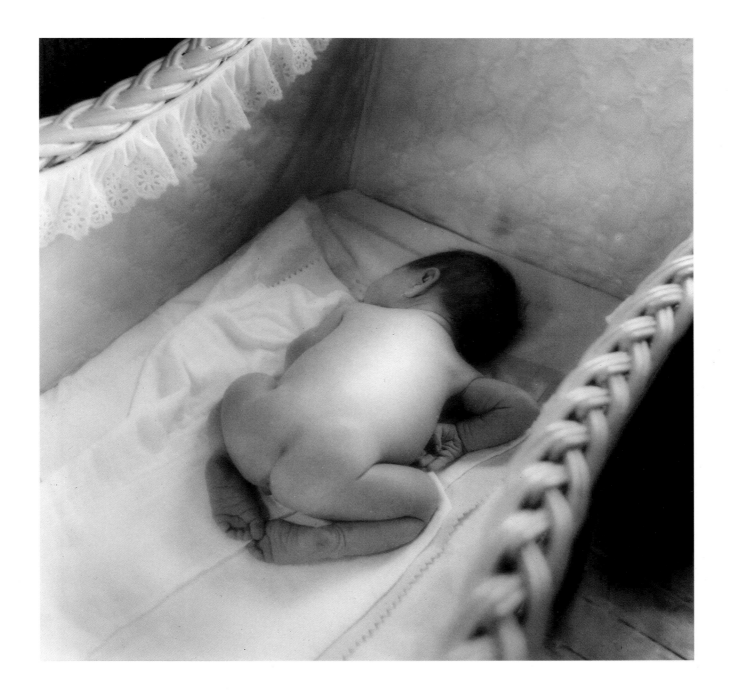

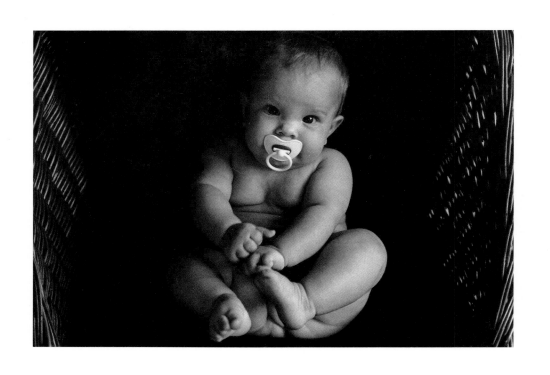

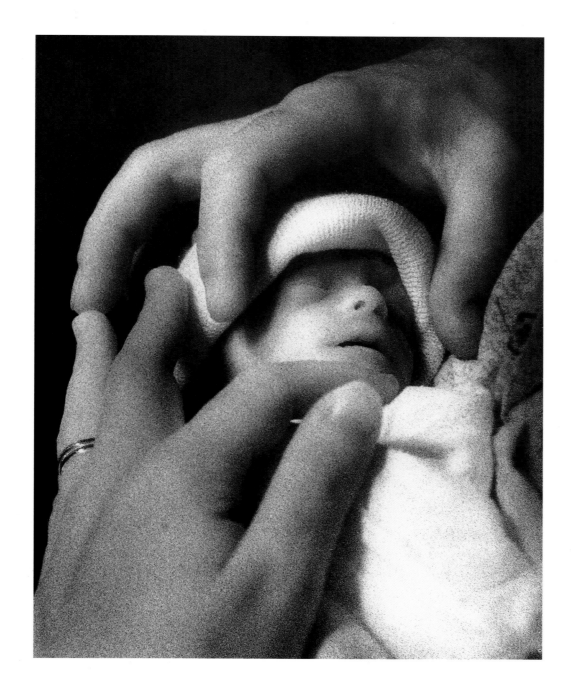

26.

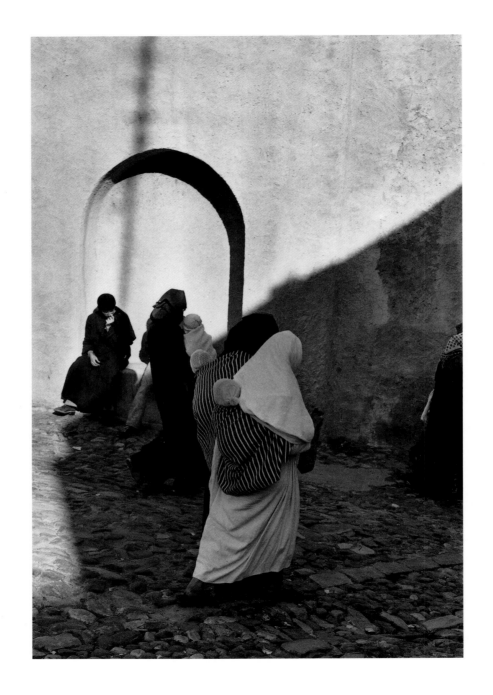

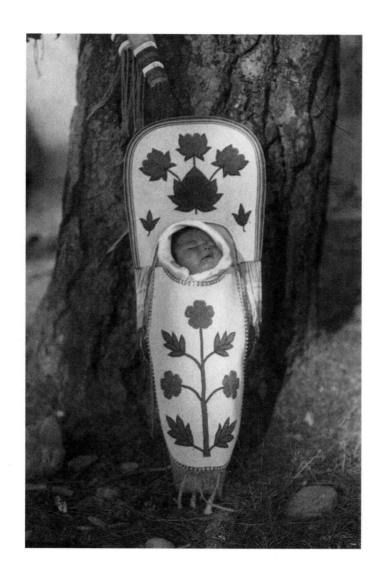

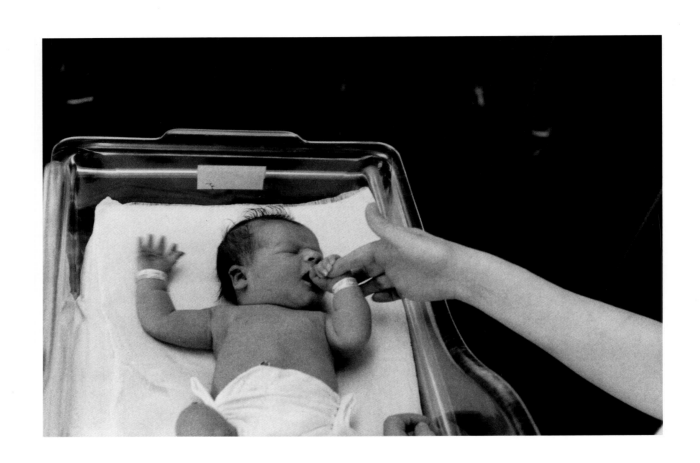

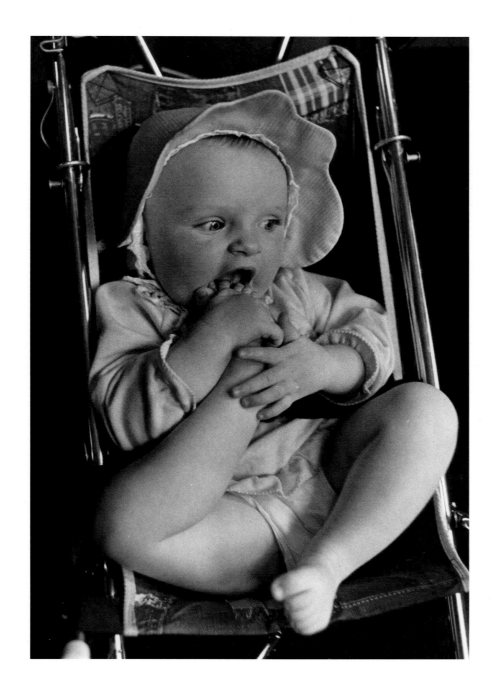

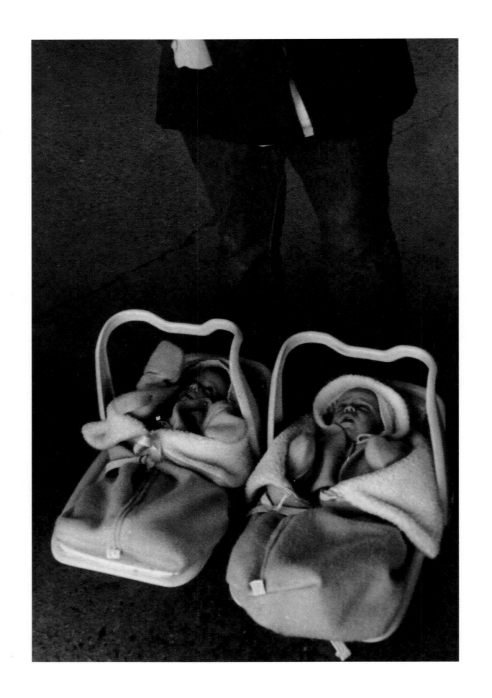

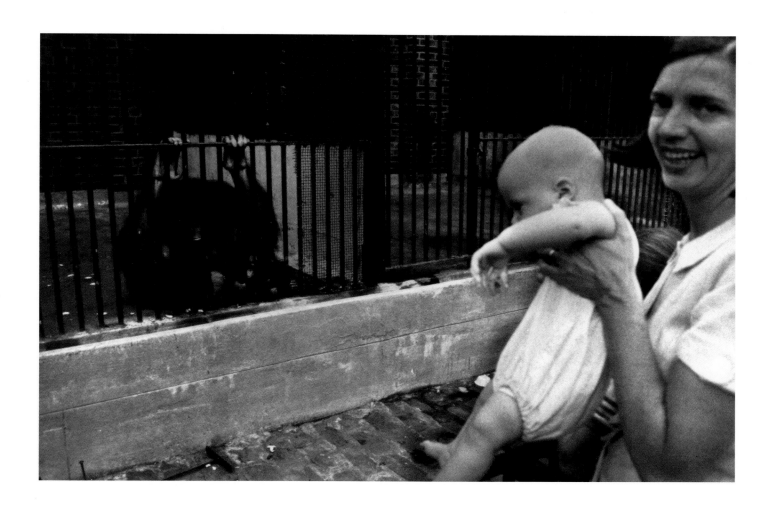

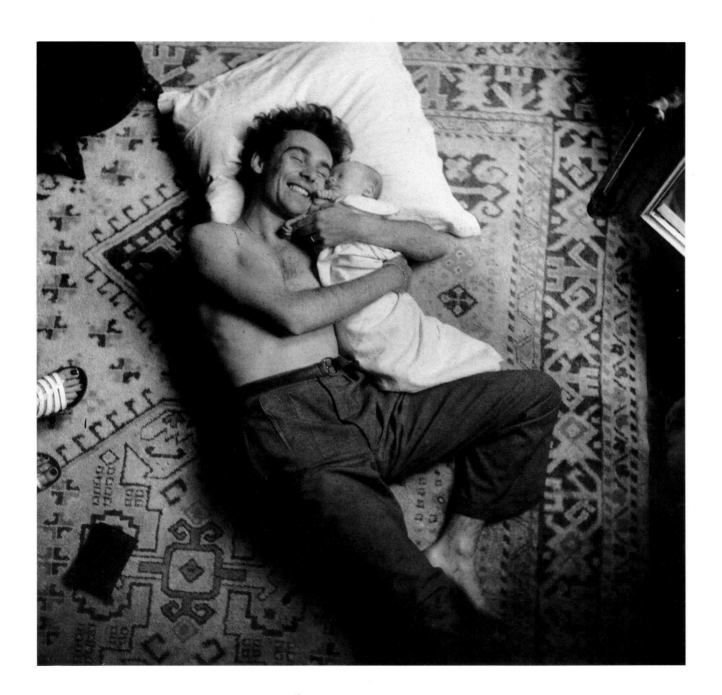

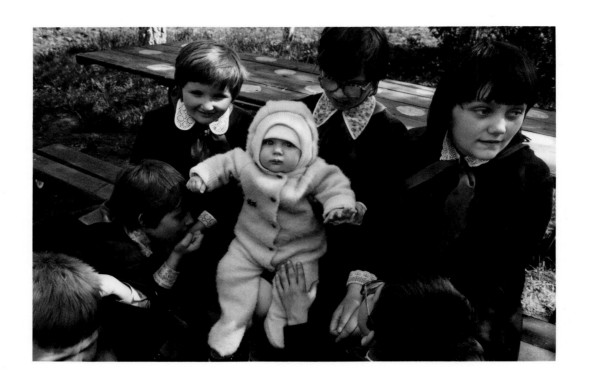

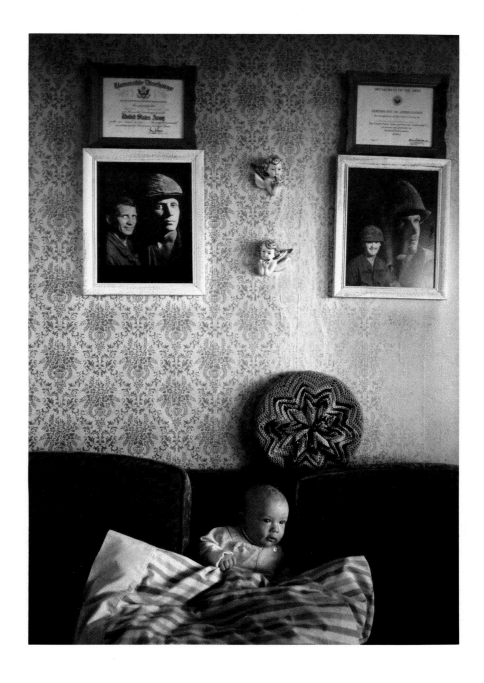

35.

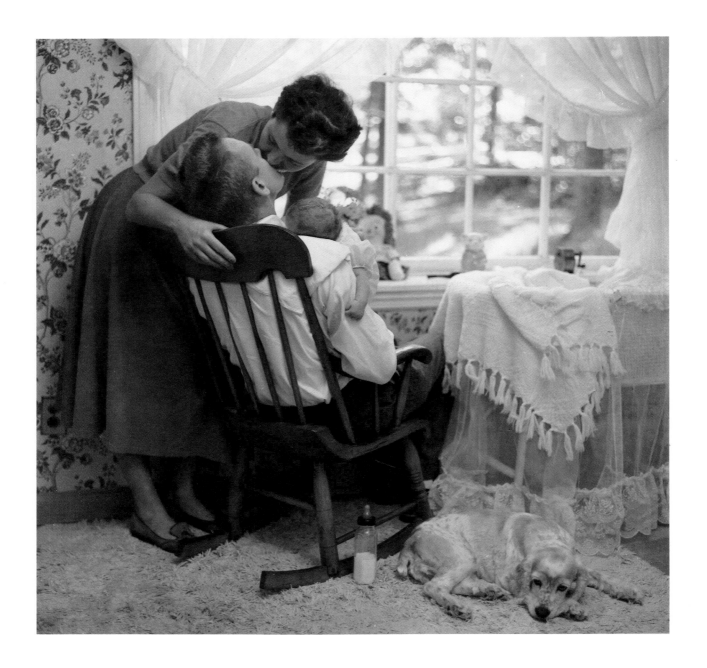

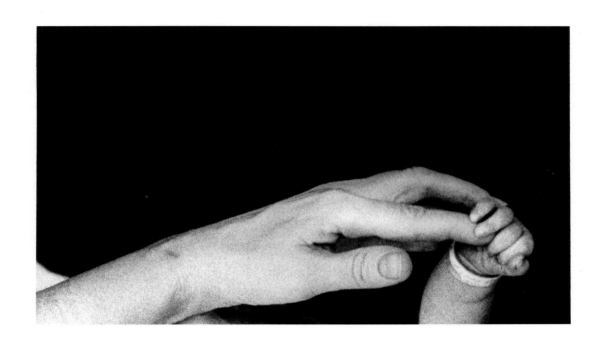

37.

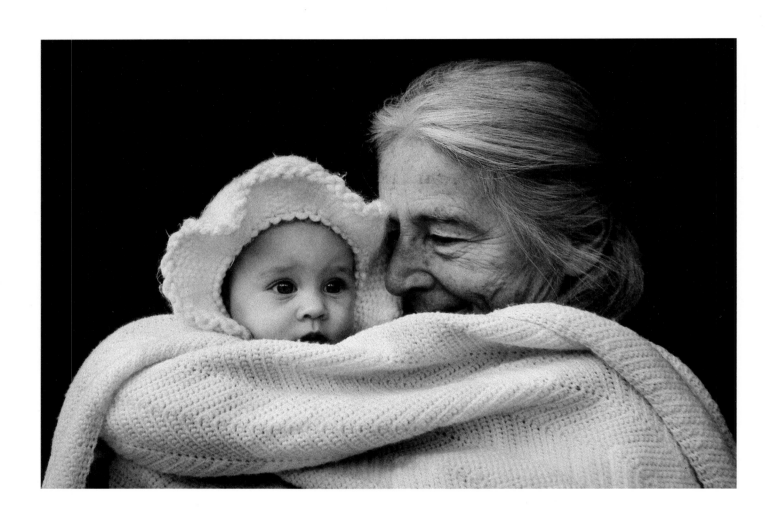

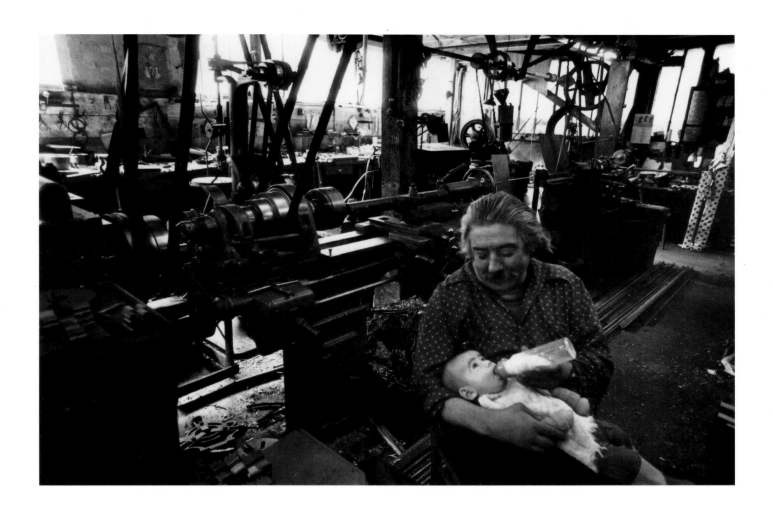

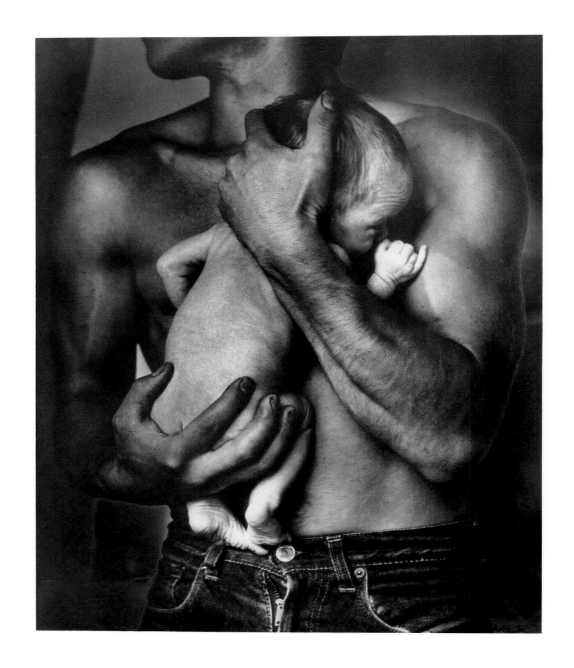

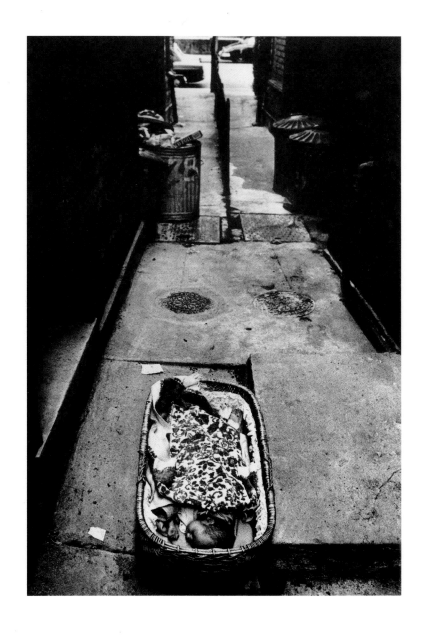

41.

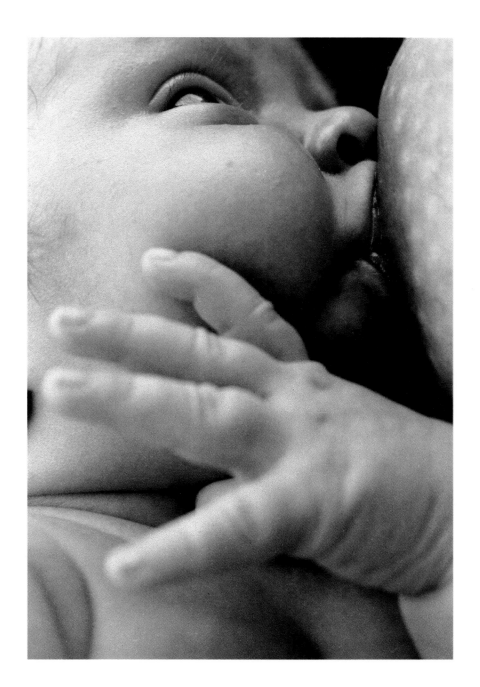

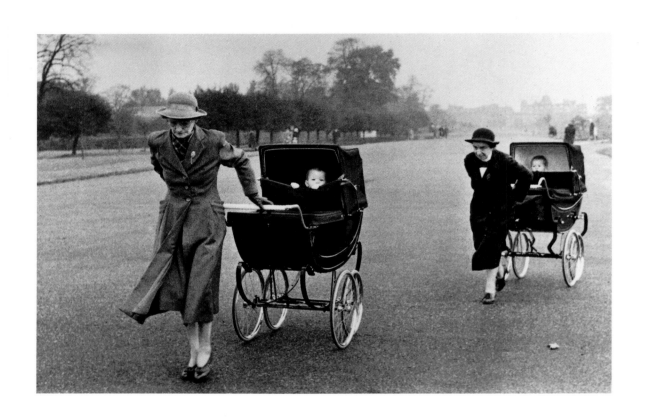

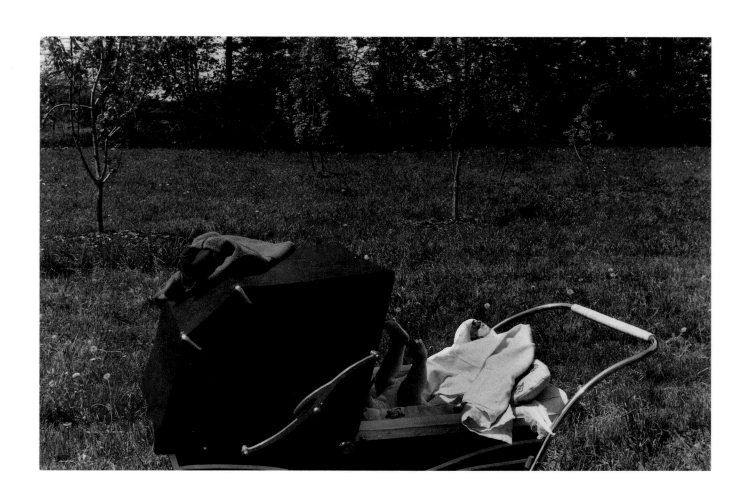

44.

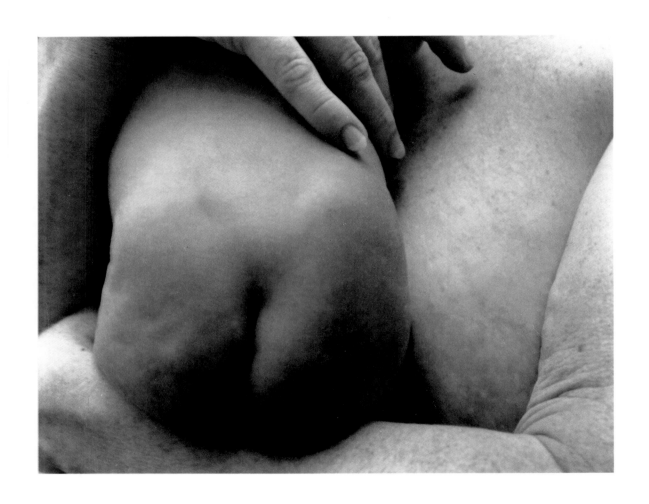

45.

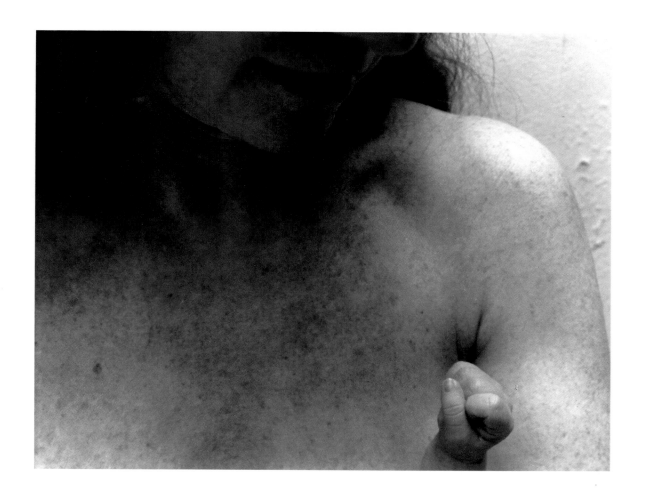

46.

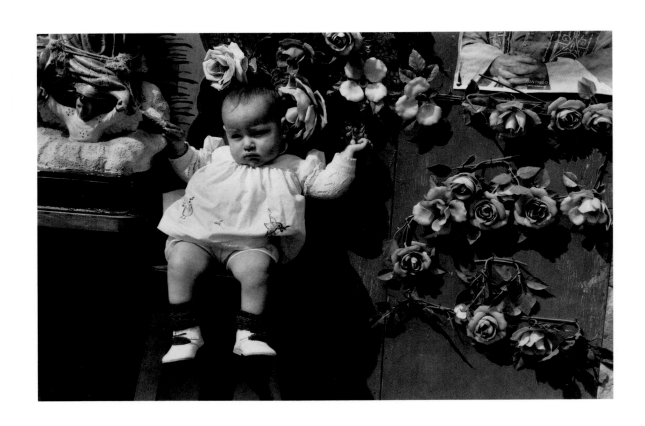

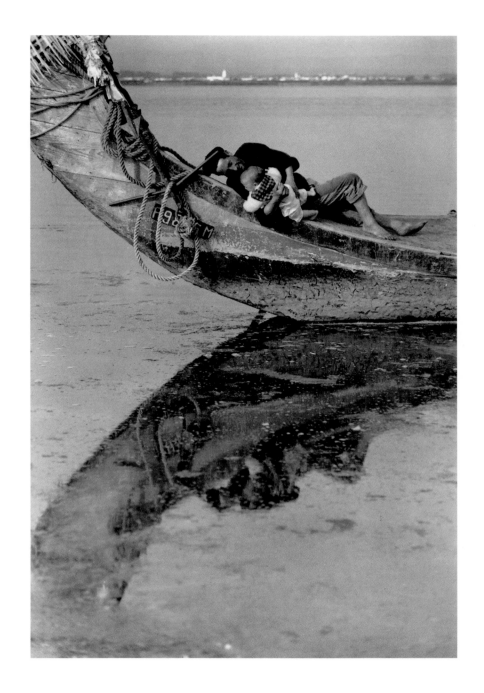

48.

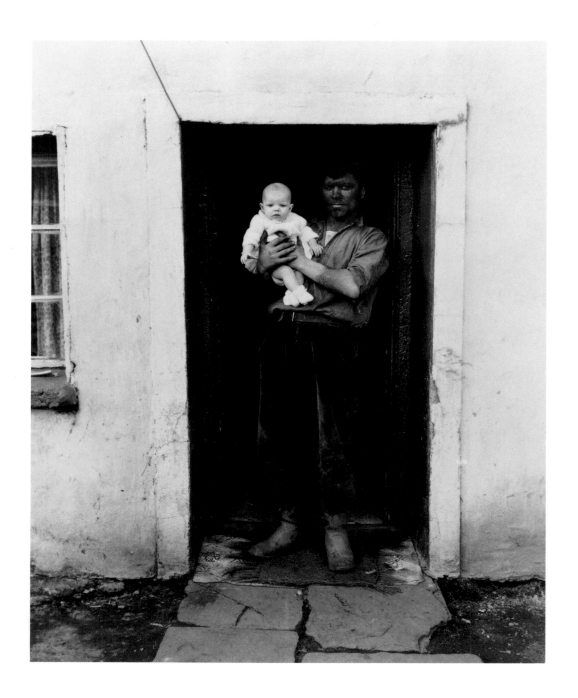

49.

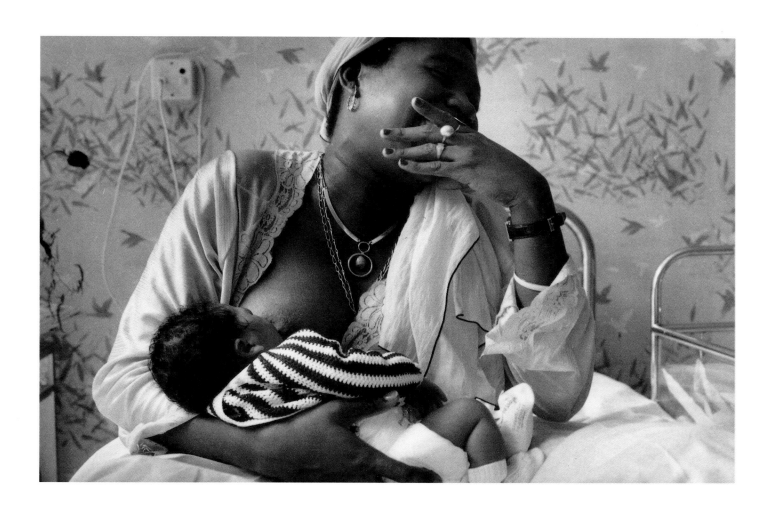

50.

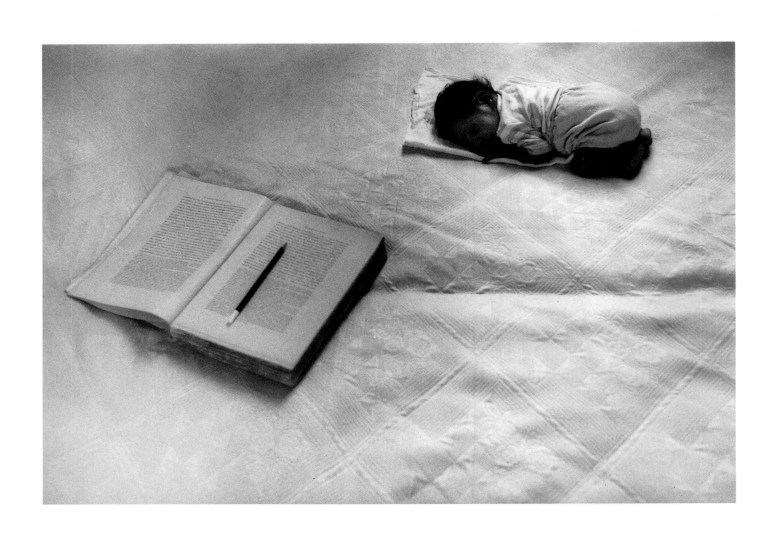

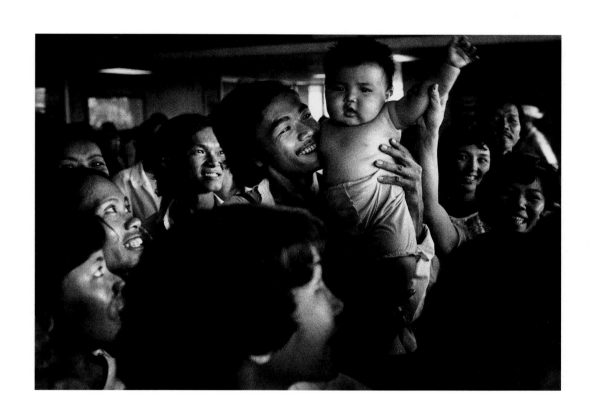

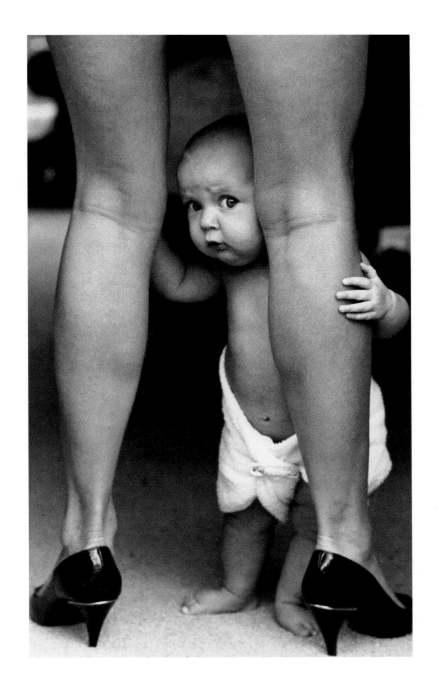

"A baby is

God's opinion

that the world

should go on."

Carl Sandburg
Recalled on his death,
July 22, 1967